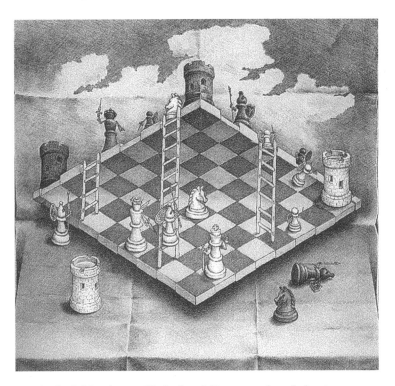

Sandro Del Prete's impossible chessboard. However much you look at it, your brain will continually struggle to reconcile the paradoxes it contains.

US edition © Wooden Books Ltd 2024
Published by Wooden Books LLC,
San Rafael, California

First published in the UK in 2007
by Wooden Books Ltd, Glastonbury, UK

Library of Congress Cataloging-in-Publication Data
McNaughton, P.
Perspective and Other Optical Illusions

Library of Congress Cataloging-in-Publication
Data has been applied for

ISBN-10: 1-952178-07-x
ISBN-13: 978-1-952178-07-8

Designed and typeset in Glastonbury, UK

Printed in India on FSC® certified papers by
Quarterfold Printabilities Pvt. Ltd.

PERSPECTIVE
AND OTHER OPTICAL
ILLUSIONS

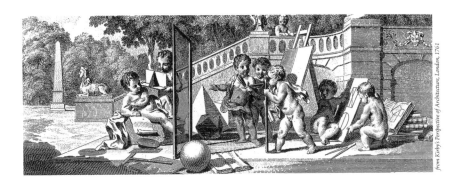

from Kirby's Perspective of Architecture, London, 1761

by

Phoebe McNaughton

to Luca

Many thanks to Dan Davidson for starting this project, to John Martineau for shifting it outside its box, to Professor Fred Dubery of the Royal Academy for his expert assistance, and to Peter Beaussart for access to his library. Original artwork on pages 12, 13, 21 & 23 by Dan Goodfellow. Pictures have been taken from a wide variety of sources, including *The Jesuit's Perspective* (Paris, 1642), *L'Atmosphère* by Camille Flammarion (Paris, 1888) and *Popular Scientific Recreations* by Gaston Tissandier (London 1885). Thanks to the M. C. Escher Company for permission to reproduce the pictures on pages 22, 33, 35, and 41 and to Professor Akiyoshi Kitaoka for permission to reproduce his pioneering work. Further reading: *Eye and Brain* by Richard Gregory, *The Science of Art* by Martin Kemp, and *New World, New Mind* by Robert Ornstein and Paul Ehrlich (Methuen 1989).

Above: One of John Ruskin's perspectival analyses of cloud formations from his Modern Painters, *London 1856. Circles in perspective are ellipses.*

CONTENTS

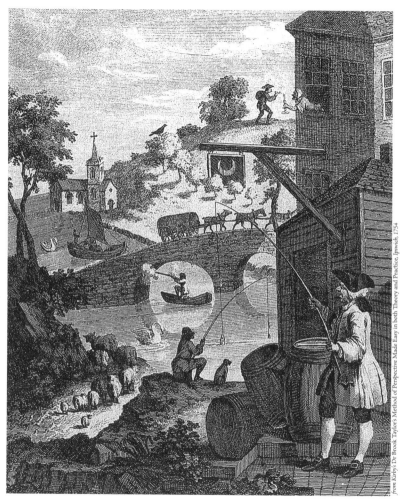

Although it looks like one at first, this is not, in fact, a normal caption, and you will find no details of strange things concerning the picture above either here, nor opposite as it happens.

from Kirby's Dr Brook Taylor's Method of Perspective Made Easy in both Theory and Practice, Ipswich, 1754

INTRODUCTION

Y OU'RE HOLDING A BOOK. Or you could be looking at a screen. Perhaps someone's reading this to you. Maybe you learned it by heart. By chance you're in a garden. In all cases you are experiencing a world with this word "now" in it which has been constructed for you by complex systems largely fed by data from your senses. Things you cannot sense you tend to be largely unaware of, and neither telling your senses to sense themselves, nor developing new ones, is going to be an easy task.

There are, right now, monks, bats, and ordinary people across the world who are accessing senses which other people, snails and cheese plants can hardly dream of. This small book uses sight, the seen world, and the many ways of reproducing it as an allegory for all our senses, although schematic systems, maps, printed circuits, technical diagrams and other widely-used representational techniques are omitted here for lack of space.

Why question the way we look at the world? Look at William Hogarth's catalogue of errors opposite. All seems well at first, but then, studying it more closely, consistent impossibilities will begin to emerge one by one. Customs have been broken, we are in a strange world, we have been tricked.

Welcome to one of the few sane disciplines (excluding eye-popping shamanics and monotonous meditations) which can actually awaken your mind to some of its invisible biases and help it become more aware of the way it constructs the world.

Welcome to the world of perspective and optical illusions.

THE DEPTH ILLUSION

a short history of points of view

PERSPECTIVE CREATES THE ILLUSION of depth on a flat surface, and its history is outlined here in three fundamental stages.

Firstly, an Egyptian wall-painting from the 1200 BC Tomb of Siptah (*below*) depicts a table seen in *elevation* (front-on), with Anubis standing behind it, reaching over with arms which *occlude*, or block out, the mummy. Front and side view orthographic (straight-on) and later oblique (slanting) projections form the backbone of world representational art from antiquity up to the Renaissance (*pages 4–9*).

The second picture (*top right, from Bettini, 1642*) shows a multi-pinhole *camera obscura* projecting perfect reversed images of the world onto a wall in a darkened room. The engraving is itself constructed in one-point perspective, with a revolutionary *vanishing point* (*pages 10–17*).

Finally, gaze through the page of a modern stereogram illusion (*below right*), merging the two white dots, until 3-D figure appears.

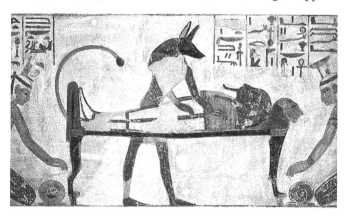

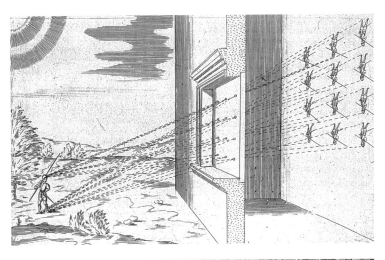

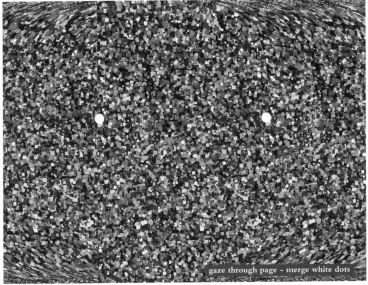

gaze through page - merge white dots

ORTHOGRAPHIC PROJECTIONS

top, front, and side views

Whether you are a caveman or an architect, a useful representation of an object or scene is often one of three simple drawings: the *plan* (top view), *section* (side view), or *elevation* (front view). That these three ancient views, correctly combined, completely define an object was first understood in the Renaissance by Paulo Uccello [1397–1475] and Albrecht Dürer [1471–1528]. Later, in 18th century France, Gaspard Monge [1746–1818] developed the method of projective geometry where the object to be drawn is placed in a box and projected (by an infinitely distant light source) on to its faces. This gave rise to two systems, the back-thrown "first angle projection" (*below left*), used in Europe during the Industrial Revolution, and the forward-thrown "third angle projection" (*below right*), which was adopted in the US.

Most cave paintings are simple elevations, showing animals and hunters seen from the side. Early maps are rough plans. By contrast, in Andrea Pozzo's 1693 picture (*opposite top*), the careful use of plan and elevation has facilitated an accurate perspective drawing, and in the picture of block machinery from *Ree's Cyclopedia* of 1820 (*lower opposite*) all three projections are shown aligned, enabling a manufacturer to take measurements directly off the drawing.

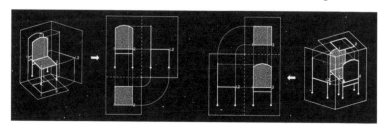

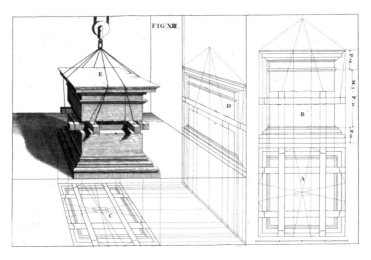

FIG. XIII.

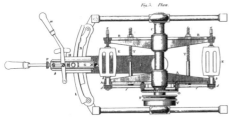

Elevation Fig. 1.

Fig. 3. Plan.

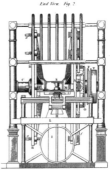

End View. Fig. 2

Fig. 4. Sliding-rest.

Gouge.

Elevation Fig. 5.

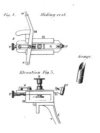

5

OBLIQUE PROJECTIONS
slightly sideways glances

With the arrival of slanting oblique projections in ancient China, India, Greece, and Egypt, all sorts of artistic possibilities flowered which were impossible in the primitive perpendicular orthographic projections of early cave, pottery and temple paintings. Now, instead of seeing an object from merely one, infinitely distant (thus divine), point of view, further divine viewpoints were glued on to the drawing. So to the side view of a chair, the front, overhead, or both views were sewn on, as though 45° sunlight was striking the object and casting a shadow, either to the side, or down, or both.

Various methods of oblique projection are shown opposite (*after Dubery and Willats*) with illustrative examples. *Foreshortening* further enhances the illusion of depth (*below*). Fascinatingly, these ways of looking at the world were all but forgotten in the West during the scramble for "real" scientific perspective until they were rediscovered by Cezanne, Bonnard, and other "modern" painters.

In Asia, oblique projections have remained in use in various traditional painting styles for over 2500 years.

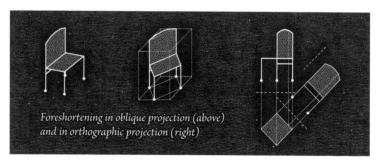

Foreshortening in oblique projection (above) and in orthographic projection (right)

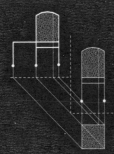

Horizontal Oblique Projection - example from Thebes, Egypt (c. 1200 BC)

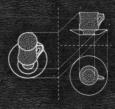

Vertical Oblique Projection - example from Punjab Hills Guler (c. 1760)

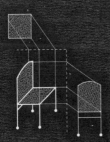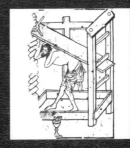

Oblique Projection - with example from German woodcut (c. 1410)

THE ISOMETRIC SYSTEM
the all-in-one hexagonal projection

A special case of oblique projection is the isometric system, which combines plan, section, and elevation drawings in a simple hexagonal grid, each separated by 60° to give a remarkably authentic picture. Developed by Sir William Farish [1759–1837] in the mid 18th century to make the complex drawings of the Industrial Revolution easier to read, isometric projections can be extended infinitely over any surface and accurate measurements taken off the drawing along all three axes.

In Louis Bretex's famous 1730s isometric map of Paris (*lower opposite*) the city extends for miles (or kilometers) in every direction, and roofs, doors and windows, and even individual trees can be seen, counted, and measured. The easily readable isometric system today survives only in popular home automobile manuals, mechanical journals, and a few other rare habitats.

Also shown (*below right*) is the related 45° *axonometric projection* with its pure plan. A few medieval and Byzantine examples exist, but this became most popular amongst 20th century designers.

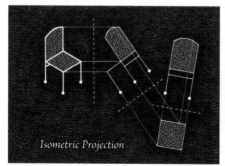

Isometric Projection

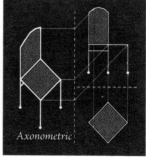

Axonometric

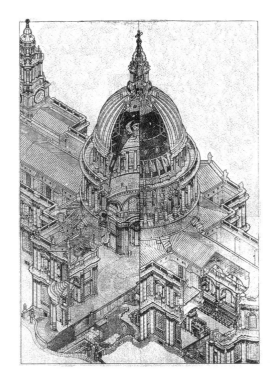

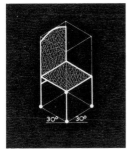

LEFT: *R. B. Brook-Greave's 1928 exercise drawing of London's St Paul's Cathedral in isometric projection.*

ABOVE: *The special isometric oblique viewing angle in which all sides appear equally foreshortened.*

BELOW: *A tiny fragment of Louis Bretex's vast isometric Turgot map of Paris, started in 1734.*

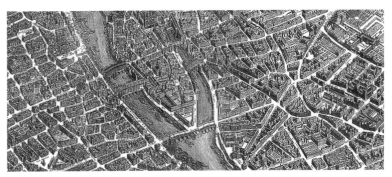

ONE-POINT PERSPECTIVE

the dot on the horizon

If you stand in front of an avenue of trees, or look down a street, the objects in front of you seem to get smaller the further away they are from you, converging on a *vanishing point* on the horizon. A system of scientific perspective based on this perception first appeared around 1405 when Filippo Brunelleschi [1377–1446] famously drew the octagonal Baptistry beside the Duomo in Florence, and noticed the way that the diagonal vanishing points framed his picture (*e.g., below*).

By 1436, in *Della Pitura*, Leon Battista Alberti [1404–1472] was able to clearly describe the fundamental principles of perspective: the fixed observing point, the central vanishing point (*vpc*), and a picture plane with two further planes set at 45° which converge to left and right vanishing points (*vpl* and *vpr*), these both the same distance from the central vanishing point as the observer from the canvas (the observer should ideally stand in this special place for maximum effect). If the viewing angle in one-point perspective is too wide then distortions occur (*lower opposite*) and for this reason it is generally limited to 60°.

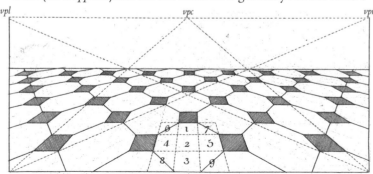

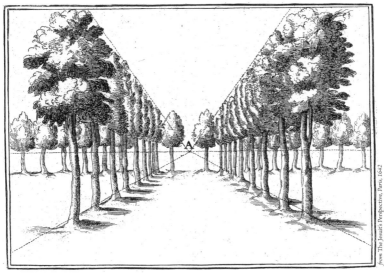

from The Jesuit's Perspective, Paris, 1642

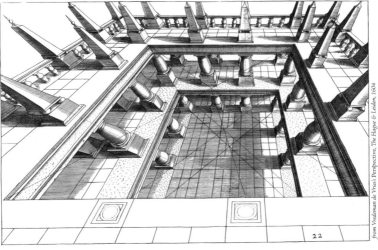

from Vredeman de Vries's Perspective, The Hague & Leiden, 1604

22

11

TWO TO FIVE POINTS
vanishing in every direction

The use of vanishing points was extended, in the centuries after their discovery, to represent space in a variety of novel ways.

Artists often employ two horizontally separated vanishing points (*shown below*), ideal for objects or views which are "corner-on." Verticals, instead of being parallel, can also be represented as converging on a point through the addition of a third vanishing point (*opposite top*), a projection often used in comic strips.

For an even more comprehensive, albeit distorted and fisheye, view of the world, try four, or even five, vanishing points, using curved space (*opposite lower left and right*).

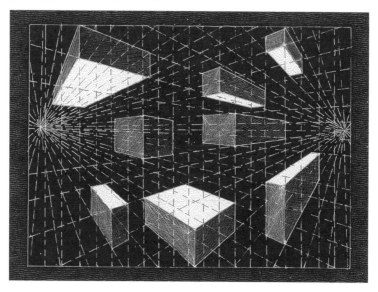

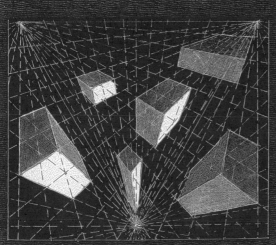

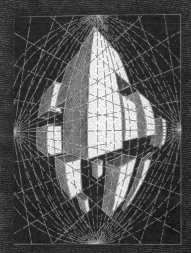

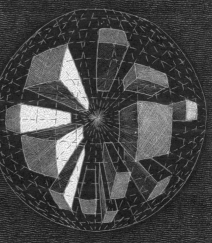

The fascinating extension of the primary geometry of perspective into two-, three-, four-, and five-point systems is shown here. From the edge-on two-point system, to the lofty three-point, the floating curved verticals of the skyscrapers of four-point, or the global fisheye lens provided by five-point, each method has a specific character, place and function, and all are easily mastered with a small amount of practice.

three-point perspective

four-point perspective

five-point perspective

DRAWING MACHINES
tricks of the trade

Today we are so used to the simple act of picking up a camera and pressing the button that we sometimes forget just how hard it was (and still is) for painters to capture the scene in front of them. Not long after the invention of perspective all sorts of clever systems began to appear to help them ever better imitate perceived reality.

By the early 16th century various methods and devices were appearing across Europe; shown here are those illustrated by Dürer in his *Underweysung der messung*. Sketches made in this way, whether by grid, or on glass, were then transferred to canvas.

Later in the century another device, the *camera obscura*, became popular. This used a lens, pinhole, or mirror to dimly project the world onto a canvas in a dark space (often requiring the artist to put his head into a cloth blackout). Used widely by painters like Vermeer in the 17th century, it suited high-contrast subjects.

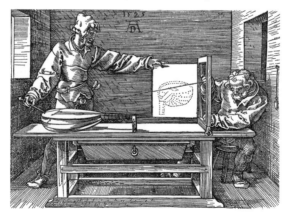

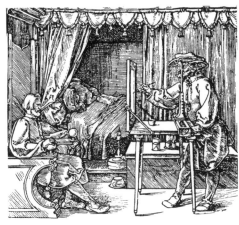

Four pictures from Dürer's Underweysung, 1525, 1538.

OPPOSITE: *Carefully plotting points to correctly foreshorten the image of a lute.*

LEFT: *Creating a painting on glass from a fixed eye position.*

BELOW: *A draftsman using a grid/net to draw a foreshortened nude figure.*

BOTTOM: *Employing a distant viewpoint perspective device invented by Jacob de Keyser.*

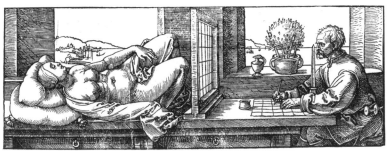

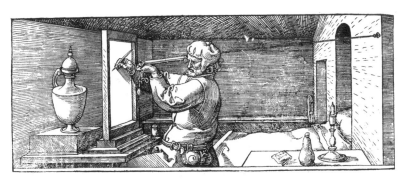

SOME PERSPECTIVE BASICS
diagonals and inclined planes

A few perspective primers are shown on this page, all of which make good exercises for an artist. Start (*opposite top*) with the simple square in the center of the image. It is completely defined from its front line, as its back corners are the intersections of diagonal dashed lines from its front corners to the central and side vanishing points. The next square away from the viewer can be positioned by the same method, and so on.

The *perspective center* of an object is obtained by drawing its diagonals and noting where they cross. It is useful for correctly positioning doors, windows, roof arches, belly-buttons, belts and noses in paintings and drawings.

Circles in perspective are always perfect ellipses. To draw them, remember that a circle sits in a square, cuts the diagonals at just over ⅔, and touches the square at points which are given by the perspective center, and the same is true for the ellipse.

Inclined planes, like shadows, use vanishing points exactly above or below the ordinary horizon vanishing points.

Below is a clue to using plan and elevation in perspective.

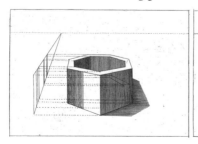 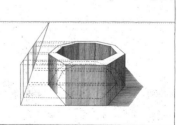

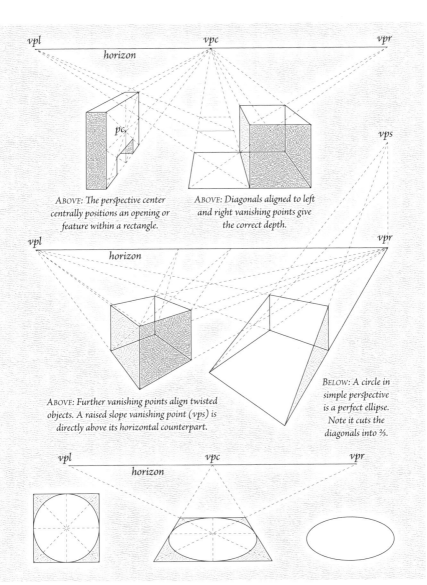

vpl *vpc* *vpr*

horizon

pc

ABOVE: The perspective center
centrally positions an opening or
feature within a rectangle.

vps

ABOVE: Diagonals aligned to left
and right vanishing points give
the correct depth.

vpl *vpr*

horizon

ABOVE: Further vanishing points align twisted
objects. A raised slope vanishing point (vps) is
directly above its horizontal counterpart.

BELOW: A circle in
simple perspective
is a perfect ellipse.
Note it cuts the
diagonals into ⅔.

vpl *vpc* *vpr*

horizon

PERSPECTIVE ILLUSIONS
when equal things seem unbalanced

The illusion created by perspective is so pervasive that it throws up all sorts of strange effects. If you hold your hands in front of you, with one at arm's length in front of one eye, and the other half arm's length in front of the other, they will still seem the same size. This is for the simple reason that your brain *knows* they are the same size. Similarly, yet conversely, in Roger Shepard's table (*opposite top left*) both tabletops are exactly the same rectangle, yet your brain distorts them based on perspectival clues in the picture.

Herringbone patterns (*opposite top right*) likewise bend perfectly parallel lines, and visible vanishing points bend the space around them causing all sorts of seeming inequalities between measurably perfectly equal elements (*below and opposite*).

Most of these illusions are noticeably weaker for traditional peoples unused to perspectival art or cityscapes, suggesting that perspective illusions are broadly brain-based hypotheses.

 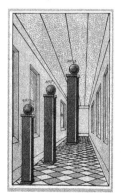 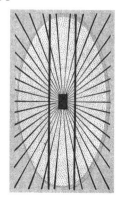

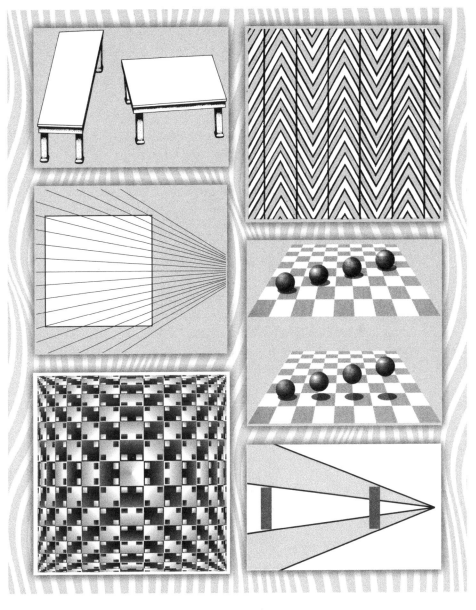

SHADOWS
and the absence of light

Accurate shadows are easy to draw in perspective and deepen the sense of realism in a drawing. Like stairways and other seemingly complex operations, if you have a go you will soon get the idea.

One of the most common forms of shadow-plotting is from orthographic projections (*see pages 4-5*). Take, for instance, the front of a house, where sunlight may be assumed to be obliquely striking the facade, casting shadows in the recesses of pillars, windows and ledges. Shadow termination lines are struck at 45° off the plan (and the side) and brought down (and across) to the elevation, enabling the correct shadows to be drawn (easier than it sounds!).

Working in scientific perspective it is important to establish whether the light source is near or far, and whether it is to the front, side, or rear of the viewer. The four basic types of situation are shown opposite, and mostly involve a small amount of study before they can be clearly grasped. Multiple light sources will obviously throw multiple shadows based along the same lines.

In a way, everything we ever see, or ever paint, or draw, is just some kind of shadow of that thing. It is never that thing itself.

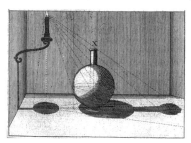 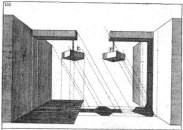

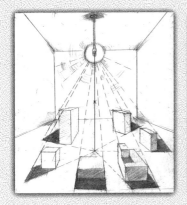 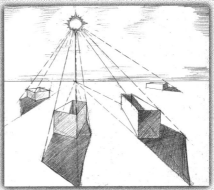

ABOVE LEFT: *A nearby point-source of light casts shadows which recede along lines from the light itself and from the point on the floor directly beneath the light.* RIGHT: *Sun in front of viewer. The vanishing point for shadows is on the horizon directly beneath the sun. Use lines from the sun to corners of objects to determine where their shadows terminate.*

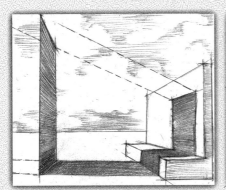 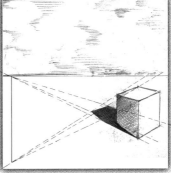

ABOVE LEFT: *Sun to the side. With light parallel to the picture plane, use horizontal and vertical extensions, along with parallel angled sloping rays, to complete the shadow.* RIGHT: *Sun behind the viewer. Determine a vanishing point for shadows on the horizon opposite to the sun, and a shadow termination point, directly below this.*

REFLECTIONS

through the looking glass

Mirrors are fascinating. Why, for instance, do they flip you left-to-right, but not turn you upside-down? They somehow hint at another world, a counterbalance to this one. Escher's beautiful 1950 study of ripples in a pond (*below*), hints at three worlds, the world of the trees themselves, the world of surfaces and reflections, and the world of fishes below.

Why do we speak of "reflecting" on something? Is the mind some kind of surface? Are perceptions merely reflections?

The answer to the question at the start of this page is that mirrors don't flip you—your right side is shown to the right, your left to the left, your top at the top and your feet at the bottom!

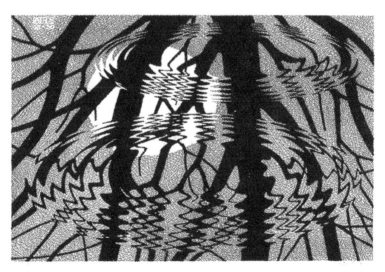

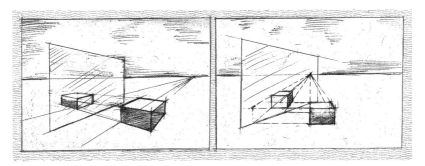

ABOVE: *A rectilinear object parallel to a mirror is easy to draw in reflection, as is the same object set at 45° to a mirror plane. Further mirror angles require the vanishing points to be carefully established.* BELOW: *Reflections in water.*

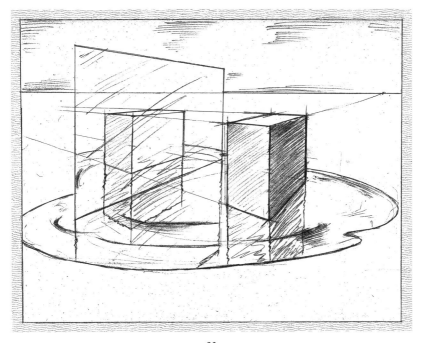

Mirages and Projections
nature working on a larger scale

Shadows and reflections occasionally reappear in nature in remarkable, almost magical circumstances. Tempting reflections known as *mirages* have long been known to haunt the thirsty desert explorer, and a hot road surface likewise takes on a mirror-like appearance from low angles on a dry day, with illusory puddles perfectly reflecting the sky and overhead bridges. Stratified layers of air function as an overhead mirror not only in deserts but sometimes show a city its own reflection in the sky (*see Paris opposite top left*), or reveal a hidden navy fleet to its enemy (*lower opposite*).

Standing on a hill-top at sunset under special conditions can give rise to a huge shadow cast on to the clouds, an effect known as the "Shadow of the Brocken" (*opposite top right, and below*). A related effect is the "aura" or glow which can appear centered on the head of one's shadow when cast by moonlight on a misty or dewy night (*opposite centre left*).

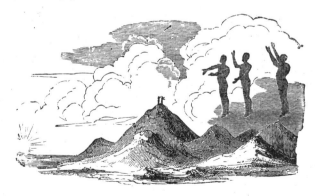

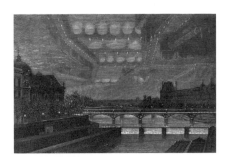

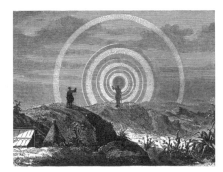

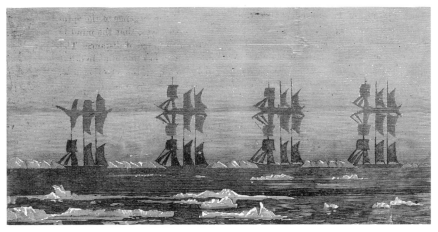

LIGHT ON FORM
tonal illusions of the third-dimensional kind

We glean information about the form of objects not only from the shadows that they cast (*below*), but also through the subtle shades that appear on their surfaces. All materials, whether glass, wood, metal or plastic, have different reflective properties and opacities which we instinctively read. The merest hint of graded shades gives the eyes subtle clues as to the form, depth and substance of an object, and, with the addition of reflections, can also indicate the positions of other light sources and nearby objects.

In the Victorian engineering engravings opposite, a simple outline has been given three-dimensionality by the use of shade, here as a textured tone. Tones may be scale illusory, as in fine cross-hatches (the engravers' preference) or printers' halftones (newspaper dots), or actual shades (in paintings or computer screens).

Luminosity is a factor in color (along with hue), and when two colors, say red and green, are *equiluminescent* they appear the same gray in a black-and-white photograph. Artists sometimes use this to place "wrong" colors of the "right" luminosity in paintings, to confuse your color-blind "what" system while engaging your "where" system.

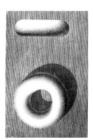 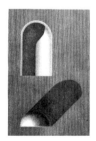 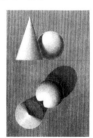 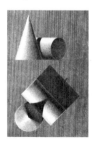

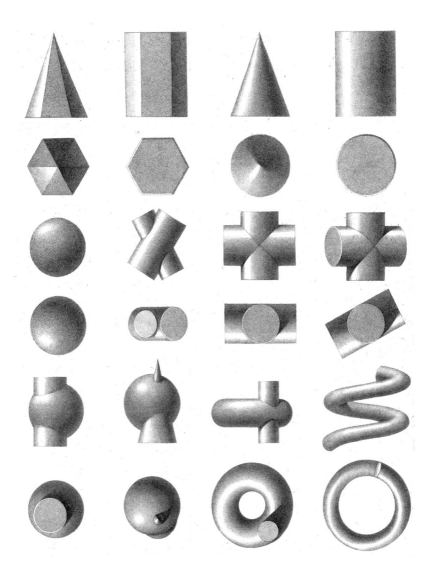

ATMOSPHERIC PERSPECTIVE
and depth of focus

Another way the mind reads distance and depth is by the extent to which atmospheric or aerial perspective is brought into play. In the diagram (*below*) the trees are all drawn to the same scale, yet the fainter ones are perceived as being more distant. Particulate matter, whether water droplets (as in fog, mist or spray) or smoke or dust particles have the effect of washing out color saturation and contrast, and on a clear day distant objects are less red, more green-blue-purple. In fog or smoke we may speak of a *vanishing plane*, as objects beyond a certain distance are invisible to the viewer.

Focus perspective, not shown here, is another trick in the illusionist's chest. Out-of-focus or blurry objects, relative to defined in-focus ones, are interpreted by the mind as either close foreground or deep background to the sharp objects depending on certain clues. Some modern artists play with this to great effect.

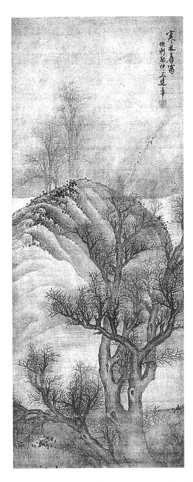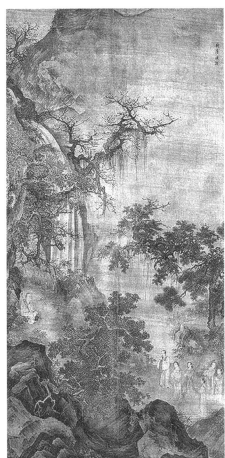

ABOVE: *Atmospheric perspective is widely used in landscape painting. In these pictures by Chinese painters Wang Chien-chang (17th C) and Lou Guan (13th C) we can see the suggestion of distance by the washing out of contrasts and hues in the more distant objects by fog, mountain mists, or waterfall sprays. Again, the mind fills in what the eye cannot see.*

RELATIVITY RULES
compared to what

Most perceptions are relative. Have you ever experienced a moment of panic, stuck in a car in heavy traffic, when a truck slowly passes by but gives the impression that *you* are rolling backwards? Likewise, if you place one hand in a bowl of hot water, and the other in a bowl of cold, then remove and plunge them into some tepid water, each will give you a response *relative* to its immediate past, not an objective impression. Then there is the strange case of large and small objects which weigh exactly the same—the larger ones feel considerably lighter than the smaller, just because we *expect* them to weigh more. In a related example (*below*) the two central circles are the same size.

In the powerful tone diagrams opposite, you can actually perceive yourself perceiving tones relative to their background as you struggle with changing tones where there are none. Try covering up the shaded backgrounds to remove the effects.

Likewise, wealth, personal morality, and happiness levels are all experienced as largely relative to those of your close peers.

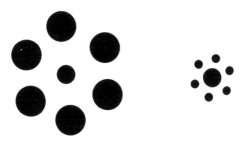

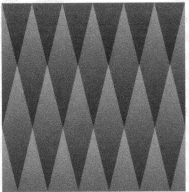

Identical rhombs appear lighter at the bottom.

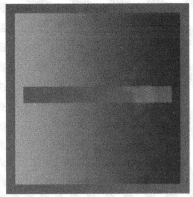

A solid tone bar appears lighter on the right.

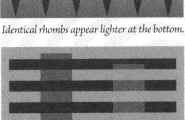

The small rectangles are all the same shade.

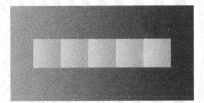

Identical squares seem lighter on the right.

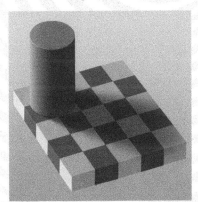

The dark squares outside the shadow are the same shade as the light squares in the shadow.

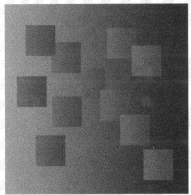

The squares are all the same shade but appear darker on the left, lighter on the right.

FIGURE AND GROUND
either or this not that

The illustrations on this page all show images that are simul-taneously two things at once—not a state of affairs our brains enjoy much, so they flip between the two interpretations for us. It is almost impossible to see Napoleon (*opposite top left*) without the trees momentarily becoming a background, and once the trees are studied, Napoleon becomes thin air again. Likewise with the reversing boxes, 13-B puzzle, duck-rabbit, and old and young man and woman below; if your brain allows a second opinion it will try it out to the exclusion of the first. The dangers of alcohol (*opposite top right*) similarly take on a Jekyll/ Hyde quality.

Fascinated by this flipping, Escher captured and time-slowed it in his 1938 engraving *Day and Night* (*opposite*), where the black and white points of view become each other's backgrounds.

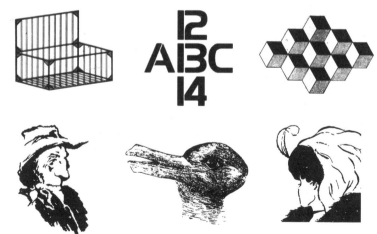

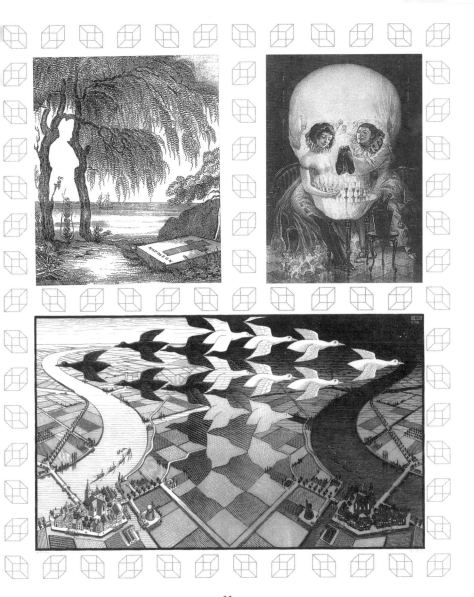

IMPOSSIBLE OBJECTS
and a fable for the certain

A king, debating the nature of reality with a sage, decided to show him the objective nature of truth. He set up a gallows on the bridge into his castle, and stationed two guards to question people there. If they told the truth they could pass, but if they lied they were to be hung. In this way truth would be upheld. The following day, the sage approached the castle. The guards asked him his business. "I am on my way to be hanged," he said. They scratched their heads. "If we let him through he will have lied," said one. "But if we hang him, he will have been telling the truth," said the other. Thus the paradoxical and relative nature of things was shown to the king.

Impossible objects similarly confound our certainty of the world by impossibly contradicting themselves. Some only work from one point of view. Like the paradoxical objects of the quantum realm, they neatly demonstrate that over-simplistic perceptions of the world are almost certainly narrow, cartoon-like, and illusory, and that more subtle perceptions may be helpful.

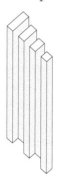 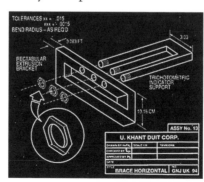

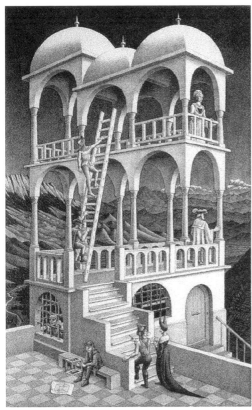

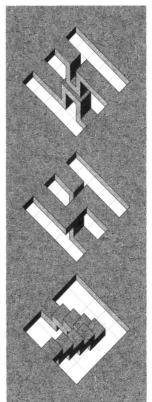

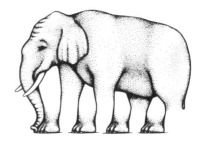

ABOVE LEFT: *One of M.C. Escher's (1898-1972) famous impossible buildings, here his Belvedere lithograph from 1958.* ABOVE RIGHT: *Three impossible figures based on the work of Swedish artist Oscar Reutersvärd (1915-2002) who drew impossible objects throughout his life.* RIGHT: *Shepard's elephant looks normal at first glance, but is it really okay? Why does the brain struggle so hard to make sense of it?*

35

CONTEXTUAL CLUES
seeing what you're looking for

It is not easy to see things as they really are. The mind continually attempts to overlay the safe and predictable reality it expects. Take the words in the picture (*opposite top*); try and repeatedly read aloud the colors of the type, rather than the words. Confused? Look at the white triangles below, except there are no white triangles. Can you see a face in the rock (*opposite lower left*)? If you're not careful you could start seeing faces everywhere. How many interpretations of the archaeological survey (*opposite lower right*) can you find? And what about the image below (*center*)? Once you have seen what it is, your brain will never cease to remind you when you look at it. Why do we look for patterns quite so much?

From childhood, patterns of materials, shapes and functions sink in, so that years later when we see a ceramic bowl, we know it will hold soup, smash if it is dropped, and can even imagine the side of it we cannot see. Our roles in life, choices of friends, enemies, partners, political parties, tastes and personal habits are all limited by illusory patterns we have reinforced with our experiences.

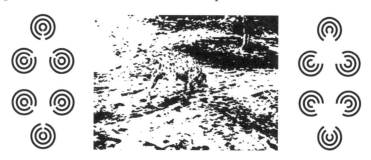

BLACK WHITE BLACK
WHITE BLACK WHITE
BLACK WHITE BLACK
WHITE BLACK WHITE
BLACK WHITE BLACK

ABOVE : *Quickly say aloud the colors of the words, not the words themselves. The automatic nature of pattern recognition gets in the way.* BELOW LEFT : *This natural rock near Chermoog in Armenia shows the face of the 5th century Saint Vartan (from Simulacra, by John Michell).* BELOW RIGHT : *The brain continually hypothesizes about what the eyes see. Here various possible huts from one survey (after Richard Gregory).*

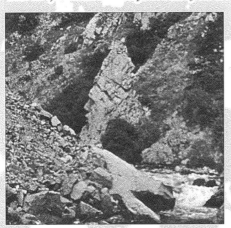

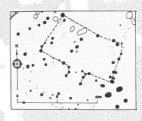

THE CARTOONING MIND
pressing the right buttons

Our brains have changed very little since the time we were cavemen. We like to think of ourselves as civilized, advanced kinds of folk, but the truth of the matter is that our attention is still easily grabbed by exactly the same basic things as thousands of years ago (*opposite*). These conceptual cartoons, "us/them," "this/that," "better/worse," "danger," or "sex" underlie many of our programmed biases, and are regularly accessed by storytellers, advertisers, and politicians. They are all essentially illusory, and it can be a valuable exercise to attempt to see them as such.

In particular, we evolved to respond to immediate personal crises, rather than slowly advancing global ones. This is one reason why, as a species, we find it so hard to stop our current destruction of Eden. A frog, placed in a pan of water slowly heated to boiling, will not jump out to save itself, instead boiling to death, because, like us, it is hard-wired to recognize only *sudden* changes as profoundly dangerous. Similarly, a hungry frog surrounded by sleeping flies will starve to death—the flies aren't buzzing about so it can't see them.

Optical illusions are one of the easiest ways of getting your brain to realize just how clichéd and prejudiced it has probably become.

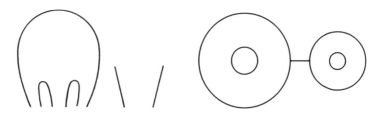

TALKS RESUME AS POWERFUL NEW WEAPON IS DISCOVERED BY IDIOTS NEXT DOOR

New faster method of travel discovered

Queen gives birth to baby boy - both doing very well

POISONOUS EFFECTS OF COMMON FOOD SHOCK

Celebrity injured in action foul play widely suspected

New organic product increases sex appeal

DOOM IMMINENT - UNLESS WE CHANGE NOW EXPERTS WARN

BABY SNATCHED WHILE MOTHER'S BACK IS TURNED

BARE BREASTS BARED

Immigrants threaten to take over says chief

WILD BEAST ATTACKS COUPLE IN THEIR HOME

Our national superiority proven yet again - latest

YOUR FUTURE CLEAR ASTROLOGY INSIDE

Incredible recipe's healing powers makes skin younger doctors claim

FOOD SHORTAGES AS RAINS FAIL

Lucian, Bristol 1988

ABOVE: *These headlines could apply to events in any period of history from primitive times to the present. All play on cartoon hopes and fears. Male and female minds fill in assumed details from limited information to an astonishing degree.* OPPOSITE: *Washerwoman & pail (after Gregory); Mexican frying an egg.*

UPSIDE DOWN

left to right and round about

Our brains construct an incredibly real world for us. Most people can navigate their homes in the dark, picturing a shelf and its objects. Even with the lights on, it may be said that the world basically exists *within* us, and probably very differently in each of us too. So to help the mind realize what it is doing, why not try turning the world inside out, back to front, or possibly upside down?

The pictures on this page all show a different take on things when simply rotated. The images below, and the two small faces opposite require a rotation of 180°. Escher's lithograph of staircases has three-fold rotational viewing possibilities (*opposite top left*), and Johann Martin Will's 1780 zoomorphic engraving displays a hidden animal when rotated clockwise by just 90° (*opposite below*).

The odd one out is the Margaret Thatcher image (*below*). Special areas of the brain that deal with eyes and mouths are much more interested in them alone than whether they are in the right place.

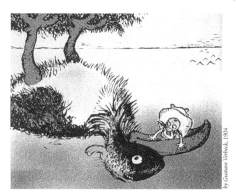
by Gustave Verbeck, 1904

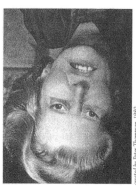
created by Peter Thompson, 1980

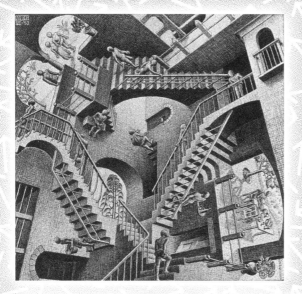

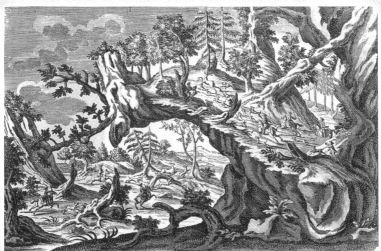

MAKING SENSE OF THE LIGHT
centers, curves, and edges

Many people assume that their eyes resemble cameras, projecting the world into their heads for them to watch. The truth is, of course, much stranger, for what inner eyes could be watching anyway?

Human eyes are much more complex than cameras. If you hold red and blue balls out at 90° (to your side) you can see them but not tell their colors apart, as your peripheral vision is specialized for spotting motion, not color. Your central vision, by contrast, is specialized for fine detail and color (try reading something you are not looking at). Center-surround arrays of photoreceptors (*shown opposite*) only fire when unbalanced by an edge or point of light crossing them. These have their color counterparts too, and combine to build curved edges and areas.

As we turn our heads or move our eyes the world stays remarkably stable outside us. Wear a pair of inverting spectacles that turn the world upside down, and lo! after a few days your brain will turn it the right way up again (until you take the glasses off). Our minds even kindly fill our blind spots with informed fiction (*lowest opposite*). The world is an informed hypothesis.

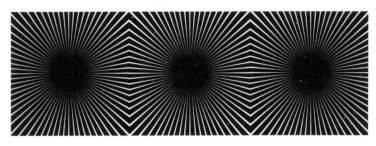

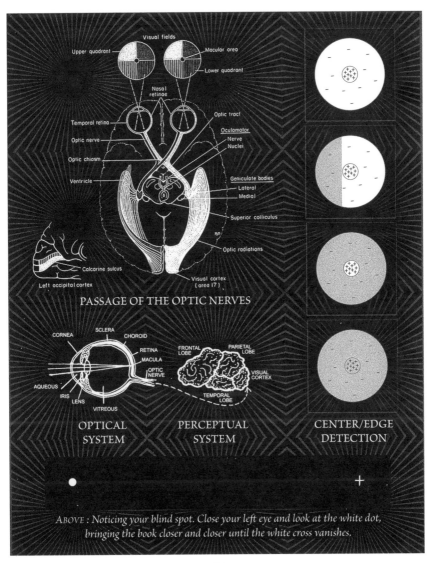

Visual fields

Upper quadrant

Macular area

Lower quadrant

Nasal retinae

Temporal retina

Optic tract

Optic nerve

Oculomotor
Nerve
Nuclei

Optic chiasm

Geniculate bodies
Lateral
Medial

Ventricle

Superior colliculus

Optic radiations

Calcarine sulcus

Visual cortex
(area 17)

Left occipital cortex

PASSAGE OF THE OPTIC NERVES

CORNEA SCLERA CHOROID

RETINA

MACULA

FRONTAL LOBE PARIETAL LOBE

OPTIC NERVE

VISUAL CORTEX

AQUEOUS

IRIS LENS VITREOUS

TEMPORAL LOBE

OPTICAL
SYSTEM

PERCEPTUAL
SYSTEM

CENTER/EDGE
DETECTION

ABOVE : *Noticing your blind spot. Close your left eye and look at the white dot, bringing the book closer and closer until the white cross vanishes.*

PERCEPTUAL ILLUSIONS
malfunctional clues to the system

There are some illusions that really show up the cracks and biases in our visual system, and a few are presented here. You may need to bring the book a bit closer to your eyes for them to work.

Focus on the dot at the center of either one of the circles below and watch as your eyes grow bored of registering the subtle grays. Next observe the excitation and inhibition operation of your eyes' center-surround cells in the pictures on the top row opposite.

Separate areas of the brain deal with *what* things are and *where* they are. Your slow "where" system is best at dealing with motion, depth, space and figure/ground perception, whereas your fast "what" system is color-blind and much more sensitive to high contrasts. Kitaoka's illusion (*center left*) uses this to great effect.

Center-surround cells are themselves grouped into oriented arrays, which detect curves and angles. The final three images opposite all play on this to create powerful illusions where circles seem like spirals, and straight lines appear warped, or broken.

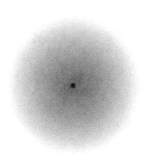 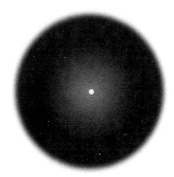

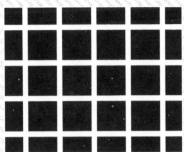

The Hermann Grid illusion.

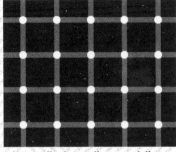

The Lingelbach scintillating grid illusion.

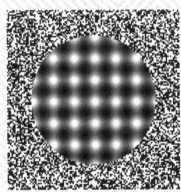

Kitaoka's two surfaces illusion

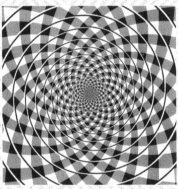

The Fraser Spiral illusion.

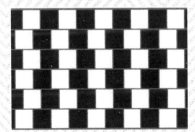

The Bristol Café Wall illusion.

The Poggendorf illusion.

MOTION ILLUSIONS

the page appeared to be breathing, doctor

You do not have to resort to drugs, psychosis, or meditation to have an alternative experience of reality. The illusions shown here are based on the recent work of Akiyoshi Kitaoka, and can seriously affect your universe as they dance, breathe, and rotate.

From the go-faster stripes on shoes to the cartoonist's just-been-there whizz lines, the illusion of motion is a constant challenge to artists and designers. Spokes on a wheel vanish as it spins faster, and blurred objects are often interpreted as moving. Computer and television screens need to be completely redrawn every twenty-fifth of a second to fool your brain into seeing a continuous moving image. Many simple organisms only see things when they change, and most people are highly stimulated by motion (e.g., driving a car). Some people get hooked on flux, others fear it, while Taoists and Buddhists recommend sitting by a waterfall and contemplating life as stillness in motion.

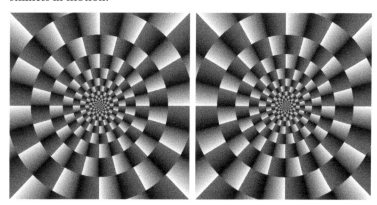

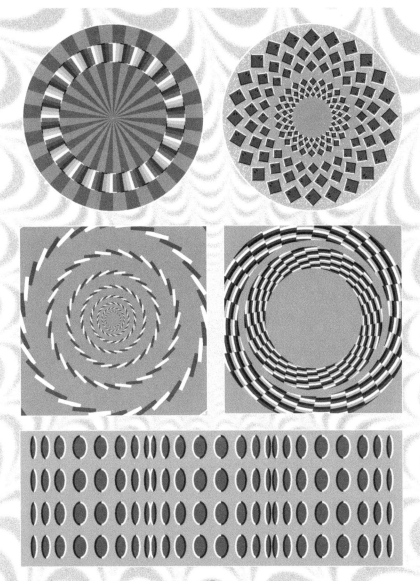

IT'S MAGIC
the highest and lowest forms of trickery

Sometimes things happen which seem impossible. When the writing on the wall appeared at Belshazzar's Feast, while some read it, and others either called for more or ran away in terror, at least a few must have wondered how it was done. Just as our senses can be fooled, so can our expectations of what is possible. The pictures shown here are all well-known effects that seem magical if one does not know their secrets. Particularly entrancing to the mind are manifestations or disappearances, which tend to be explained away as having either psychological (hallucinatory), technological (trickery or alien), or spiritual (divine or psychic) causes.

The glass in the stage ghost illusion (*below*) is a great metaphor.

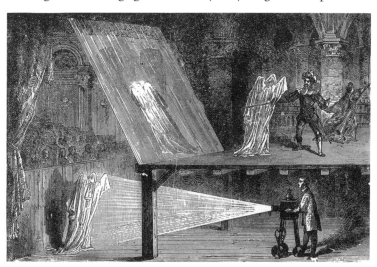

48

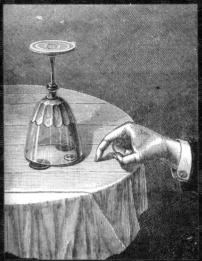 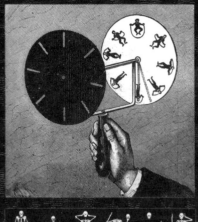

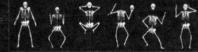

ABOVE LEFT : Scratching a tablecloth causes a coin to move from under a glass. ABOVE RIGHT : Joseph Ferdinand Plateau's revolutionary Phenokistoscope, which produced the illusion of moving pictures. BELOW LEFT : Alexander Graham Bell's new telephonic invention must have seemed like magic to many people. BELOW RIGHT : A Gyroscope magically defies gravity.

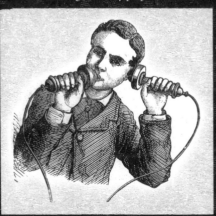 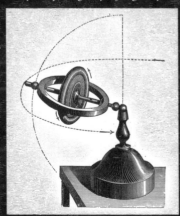

OTHER SENSES
seeing things differently

Next time you see a bee buzzing about a flower, stop to think that the bee is seeing a different flower than you are. Bees perceive ultraviolet light, and flowers use this fact to advertise themselves in higher frequencies (shorter wavelengths) than we can detect. The picture (*opposite top*) shows what the bee might be seeing.

Some people (1 in 10) are blessed with a strange condition called *synesthesia* where their auditory inputs, i.e., words and music, are translated into colors and shapes (*lower opposite*). They often have better memories and make better musicians than the rest of us.

Other people can clearly see the glowing auras (magnetic fields) of living things, sometimes with specific colors that give clues to their health. Some see a vertical line of glowing spinning wheels up the body (the chakras of Indian Tantra) or filigree lines and pinpricks of light (the meridians and nodal points of Chinese medicine).

We can hardly imagine what a bat really "sees" with its ears, nor how the bumps on its back might have evolved to echo sensual music to a mate. Perhaps we are really as blind as bats ourselves.

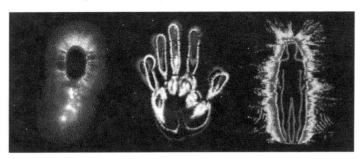

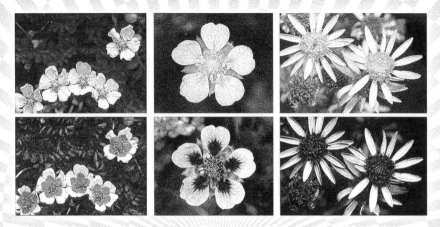

ABOVE : The top row shows three species of flower as seen by human eyes, and below, the same flowers as seen by a bee in ultraviolet (photo: Bjørn Rørslett). BELOW : An artist's impression of the kind of overlay that is seen by someone who is synesthetic, as auditory signals are processed by the visual part of the brain to produce colors and shapes. OPPOSITE : Kirlian (aura) photography.

RAINBOWS AND MOONBOWS

you never see a rainbow from the side

A rainbow (or its rarer nocturnal sister, a moonbow) is a great analogue of precisely how little we see of the world. That thin ribbon of colored light is itself an accurate snapshot of the tiny slice of the electromagnetic spectrum that our senses pick up in any detail. The rest of the spectrum (which is most of it) we are blind to, and today fill with radio, phone, and internet signals, using digital white noise (whose only natural parallel is radioactive decay).

Most things we can see are not really there, atoms being almost entirely empty space, but rainbows and lunar halos (*lower opposite*) are particularly thought-provoking because they really aren't there at all. Or are they? Like the ladder of light you see across the ocean at sunset which always points just to you, rainbows are always centered, exactly facing each individual, in a different place in the world for each observer, a kind of inversion of normal perspective and a beautiful reminder of the relativistic nature of perception.

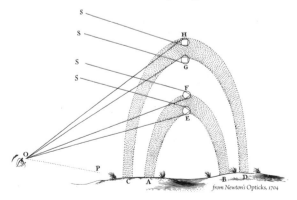

from Newton's Opticks, 1704

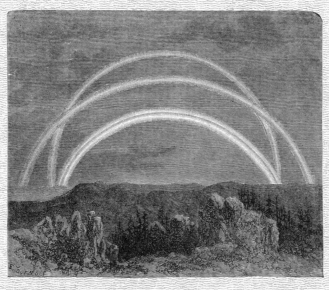

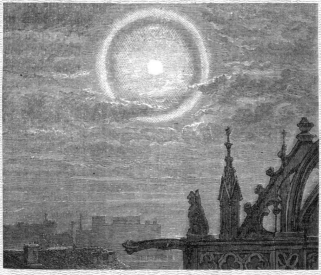

HALOS AND GLORIES
windows into other worlds

The figure opposite is from Flammarion's 1888 treatise *L'Atmosphère* and shows one of the most beautiful atmospheric effects in all of nature. Ccaused by fine ice particles high in the atmosphere, and known to the Victorians as a *glory*, it begins as *sun dogs*, two rainbow spots 22.5° each side of the sun, and will develop to its full rainbow cross under the right conditions.

Halos, glories, and rainbows are wonderful reminders that what we see is light, and light alone. Grass looks green but is in fact every color but green, green being the one color it reflects and does not absorb. The true nature of objects is hidden from us, the other side of the mirrors that reflect impressions into our eyes and minds. One of the great equations of the 20th century, Einstein's $E = mc^2$, reminds us that matter itself is merely light trapped in a place and time, dancing to laws of geometry and harmony.

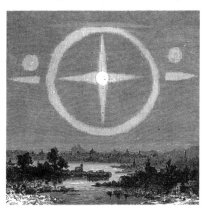

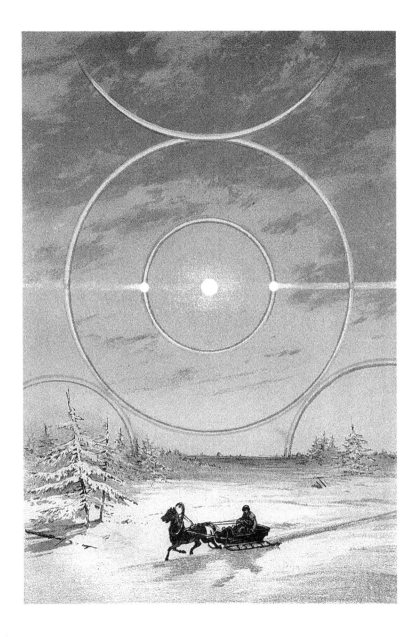

GETTING REAL
looking at the world in a new way

In *The Republic* the Greek philosopher Plato [428-347 BC] likens our lot to that of someone living in a cave, watching shadows on a wall, wondering what is casting them. It is incredible to think that the world we see is simply a product of our senses and the systems we use to make sense of them—the beautiful and extraordinary world out there is, for all non-practical purposes, still essentially a mystery. How do we really know we are not cheese plants on Venus dreaming all of this? Just because our senses are being tickled?

Perhaps this is why so many sages throughout the ages have referred to the spiritual journey as an "awakening," recommending exercises that constantly improve and refine all of our senses.

Anyway, I hope this little book has thrown some new light on these things for you, refreshed your perspective somewhat . . . See you!

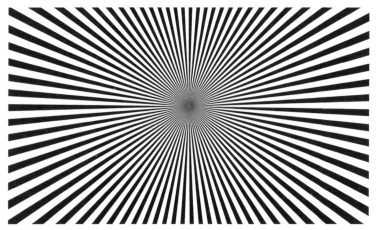

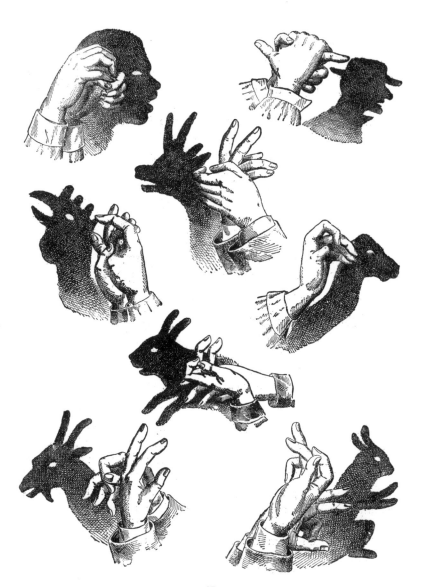

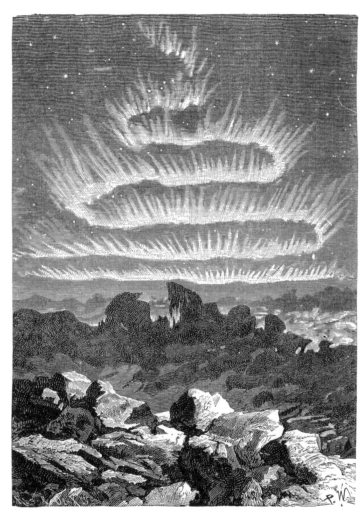

The northern lights over Iceland, a visual clue to the extraordinary electromagnetic world of which we see such a tiny part and yet our thoughts are largely made of.